BASIC ✻ ESSENTIALS™
PHOTOGRAPHY
IN THE OUTDOORS

Help Us Keep This Guide Up to Date

Every effort has been made by the author and editors to make this guide as accurate and useful as possible. However, many things can change after a guide is published—new products and information become available, regulations change, techniques evolve, etc.

We would love to hear from you concerning your experiences with this guide and how you feel it could be improved and be kept up to date. While we may not be able to respond to all comments and suggestions, we'll take them to heart and we'll also make certain to share them with the author. Please send your comments and suggestions to the following address:

The Globe Pequot Press
Reader Response/Editorial Department
P.O. Box 480
Guilford, CT 06437

Or you may e-mail us at:

editorial@globe-pequot.com

Thanks for your input!

BASIC ESSENTIALS™ SERIES

BASIC ✳ ESSENTIALS™
PHOTOGRAPHY
IN THE OUTDOORS

SECOND EDITION

JONATHAN HANSON

The Globe Pequot Press

Guilford, Connecticut

Basic Essentials is a trademark of The Globe Pequot Press.

Cover photo copyright © PhotoDisc, Inc.
Cover design by Lana Mullen
Text design by Casey Shain
Photo credits: Figures 1, 4, 5 courtesy of CONTAX/Kyocera Optics, Inc.; Figures 2, 3, 11, 12, 13, 14, 15 by Eric Gossler and Mike Wyatt; Figures 6, 7, 8 © Pentax Corporation; Figure 9 courtesy of Bogen Photo Corp.; Figure 10 courtesy of Canon; Figures 16, 17 courtesy of The Tiffen Company; Figures 18, 19 courtesy of Tamrac, Inc.; Figure 20 courtesy of Ewa-Marine.

Library of Congress Cataloging-in-Publication Data is available.

ISBN 0-7627-0522-1

Manufactured in the United States of America
Second Edition/First Printing

Contents

Preface

I remember the first roll of film I shot with my first 35mm camera. I was determined to be a professional outdoor photographer, so I took the camera out on a fine sunny day in the Arizona desert. It was spring—flowers and cacti were blooming, the trees were leafed out, and I went through that roll of film in twenty minutes, returning home with the certainty that I was on my way to fame.

But when the slides came back from the lab, something had happened. My beautiful scenes, although exposed well, were dull and void of interest. The lighting seemed harsh and glaring; flowers that seemed close when I was there looked like pinpoints in the photos; nothing in the images grabbed me the way the real scenes had. I was crushed, but I went back through all the magazines that had been my inspiration and pored over photos similar to what I had taken. Finally, a common thread hit me—most of the published pictures seemed to have been taken right after dawn, in the soft, orange light that comes with the first rays of the sun. I went out and tried again at 5:30 A.M. This roll was much better—a long way from perfect, but better.

That was my first inkling that good outdoor photography means more than just being in the right place with a camera. In the succeeding years, I've been blessed to know several superb photographers willing to share their experiences and knowledge with me. Everything I know today I owe to their generosity.

You might not aspire to professional photographer status, but have you ever been disappointed in the shots you've brought back from a hike, a vacation, or a once-in-a-lifetime trip? The information in this book will help you get better pictures out of any piece of equipment—from the simplest point-and-shoot to the zootiest motor-driven SLR. You'll find, in fact, that fancy equipment is the least important contributor to a good photograph.

Good luck and good photography.

Equipment

Cameras

35mm SLR

The 35mm single lens reflex (SLR) is by far the most popular choice of amateur and professional outdoor photographers—and with good reason. It's small and light enough to be carried in the field with extra lenses and accessories, yet it can produce high-quality prints or transparencies (slides) suitable for publication. A wide variety of interchangeable lenses allows the photographer to capture scenics, distant wildlife, or tiny insects and flowers.

When you look through the eyepiece of an SLR, you actually look right through the lens, by means of a prism and mirror (hence the term *single lens reflex*). Thus, you see exactly what the lens sees—and exactly what will appear in your photograph, whether it's a telephoto shot of a grizzly bear or a closeup of a butterfly. This makes precise composition easy to master. Only at the instant you press the shutter release does the mirror swing up out of the way, allowing the light to reach the film.

Most SLRs now are equipped with autofocus capability; that is, the camera automatically focuses the lens when you press the shutter release part way. The first autofocus cameras merely focused on whatever was in the center of the picture; recent models can focus on different areas as determined by the photographer. The latest development is eye-controlled focus—the camera actually focuses where your eye looks within the frame. In some autofocus cameras, a

motor inside the camera focuses the lens; in others, each lens has its own tiny motor, controlled by signals from the camera.

With the rapid advancements in reliable electronics and microchips, most 35mm cameras (which, by the way, are so-called because of the size of the film) boast more features than you're ever likely to need. But there are several that I've found particularly useful for outdoor photography:

Depth-of-field preview: This is a button or lever that allows you to see how much of the final shot will be in focus in front of and behind the main subject (*depth of field*).

Mirror lock-up: Being able to lock the mirror out of the way before the instant of exposure eliminates a tiny bit of vibration, helping to ensure the sharpest image. Because the viewfinder is useless with the mirror up, this feature is mainly used for scenic shots with the camera on a tripod.

Manual override of autofocus: No matter how smart your camera's autofocus system is, there will be times when you want to focus on something different from what the camera thinks you should.

There are several excellent brands of 35mm cameras. The big two as far as professionals are concerned are Nikon and Canon, both of which make an enormous variety of models. Minolta has recently introduced a pro-level camera that might give the others a run for their money. The good thing about beginning a system with these brands is that you can start with an inexpensive camera body and a few lenses, then add

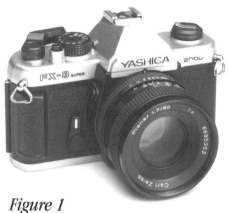

Figure 1
An entry-level SLR camera.

one of the pro bodies later if you choose. The lenses will be fully compatible.

I recommend sticking with one of these three for your first camera because of the quality and vast range in their systems, but there are other fine makes as well (see Figure 1). Pentax and Olympus are excellent Japanese products. Contax sells fine camera bodies manufactured in Japan, accompanied by best-in-the-world lenses from

Carl Zeiss in Germany. And there are the superb Leicas, also from Germany. The latter pair are frighteningly expensive, however, unless you're willing to buy used (as I do).

Tip: **Many photographers debate the merits of metal- versus plastic-body cameras. I admit to liking the feel of solid metal, which has proved its durability more than once because of accidents. However, there is some evidence indicating that plastic cameras are actually better at absorbing the shock from a sharp impact. In any case, there's certainly little difference, so don't let it sway your choice.**

Point-and-Shoot Cameras

Such cameras are called "point-and-shoot" because all you have to do to take a photo is aim and press the shutter release. Point-and-shoots are less expensive than SLRs, but the quality of the photos is not as good (although the better ones come close). Very few point-and-shoots have interchangeable lenses, and the lenses they come with tend to be designed more for light weight and low cost than optical excellence. Most point-and-shoots are range finders, which means you look through a separate eyepiece lens, not the shooting lens, to compose the picture; thus, you don't see exactly what the lens does as with an SLR. However, many point-and-shoots with zoom lenses have an eyepiece lens that zooms too, at least approximating an SLR view.

Despite their disadvantages compared with SLRs, point-and-shoots can still take good-quality photos, and their autofocus, autoexposure features make it hard to take a blurry or too-dark shot. Artistic nuances, however, are still up to you—the camera can't do anything about the tree growing out of your friend's head.

The big SLR makers also make their own point-and-shoots; in addition, film manufacturers such as Fuji produce very good versions.

APS Cameras

Advanced photo system (APS) is an entirely new format designed cooperatively by several film and camera makers. The film is smaller than 35mm, thus enlarged images cannot be as sharp, all else being equal. This precludes the use of APS by professionals—but for casual photographers the system does have its attractions. The film comes in easy-to-load cartridges (no film leaders to thread), and you can switch between three picture format normal, group, or panorama—on the same roll. The cameras are compact and simple to use. But it's still too early to tell whether APS will become an accepted alternative to 35mm for amateur photographers or a dinosaur like the Kodak Disk.

Photography in the Outdoors **3**

The wave of the future? Almost certainly. Digital cameras use no film; instead the image is recorded in digital form on a chip and then stored in a memory, similar to any other piece of information in your PC. Like any computer file, the image can be copied, printed, erased, E-mailed, or even altered.

In contrast to images recorded on traditional photographic film, a digital image comprises discrete bits of information (look closely at an image on your TV screen to get the idea). The bits are called *pixels*, and the more there are in the image, the sharper it is. Inexpensive digital cameras (less than $200) will produce an image of around 300,000 pixels. It's commonly listed as 640 x 480, meaning an image with 640 columns of pixels and 480 pixels in each column. A 3- x 4-inch print at that resolution will look like a poor-quality snapshot. Much better are the so-called megapixel cameras, with one million or more pixels (around 1,280 x 1,024 or similar). A megapixel image is much sharper, with better contrast and color. Two-megapixel cameras (1,600 x 1,200) are now available for under $1,000.

Digital photography is still in its infancy. However, it shows signs of being a very precocious child. Expect resolution to climb and prices to drop as the technology advances. At present, a $200, 35mm point-and-shoot can produce results at least as good as a $1,000 digital model, but that gap will surely narrow quickly.

Will digital imagery eventually render film obsolete? Quite possibly. But the good news for SLR owners is that many manufacturers are developing digital backs for 35mm SLR cameras that allow the use of normal lenses and accessories. So there's no reason to hold off buying an SLR system for fear the equipment itself might be obsolescent.

Lenses

The lens on your camera is the single most important component in determining the quality of the final photograph. The snazziest motor-driven SLR in the world will produce lousy pictures if you saddle it with poor-quality lenses. That's a good thing to keep in mind when figuring your budget for equipment.

Lenses are identified by their *focal length*, which is the theoretical (rarely actual) distance from the front of the lens to the film plane. The measurement is expressed in millimeters and ranges from extreme wide-angle fish-eye (7mm or 8mm) to extreme telephoto (1,000mm to 1,200mm).

The circular area of view a lens covers is known as its *field of view*. The angle between two lines drawn from opposite sides of the circle to

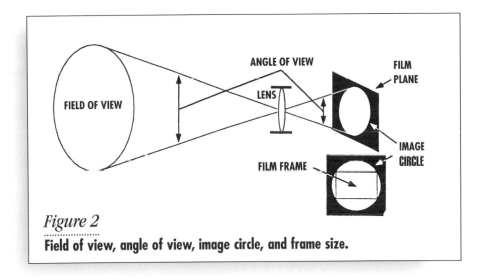

Figure 2
Field of view, angle of view, image circle, and frame size.

the lens is known as the *angle of view*. The lens projects the field of view onto the *film plane* as an *image circle*. The opening in the camera body behind the lens, called the *film frame*, defines the 24mm x 36mm portion of the image circle that will form the image on 35mm film. (See Figure 2.)

From the same camera position lenses with shorter focal lengths (see Figure 3) create smaller images of the subject with a wider field of view, while longer lenses create larger images of the subject with a narrower field of view. Lenses with focal lengths around 50mm, also known as normal lenses, present a view similar to what your eyes see—a field of view of about 46 degrees.

Wide-angle lenses (8mm to 35mm): Wide-angle lenses are extremely versatile tools for the outdoor photographer. Their wide field of view captures panoramic scenes beautifully and provides an apparent

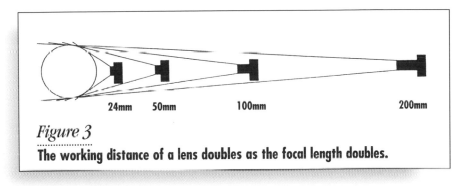

24mm 50mm 100mm 200mm

Figure 3
The working distance of a lens doubles as the focal length doubles.

increase in the depth of field, meaning everything from the close foreground to the distance can be in sharp focus. The most useful range of wide-angle lens is from 24mm to 35mm. Lenses shorter than 21mm can produce dramatic images with huge foreground objects and receding horizons, but they also produce linear distortion, turning straight lines into curves, and must be used with care.

Normal lenses (50mm to 60mm): Looked down on by many professionals, 50mm lenses have taken some of the finest photos in history. Because their field of view approximates our own field of vision, they lend themselves to easy and natural composition. Normal lenses can also be made with large maximum apertures (see chapter 2), making them helpful in low-light situations. A note here: Lenses for APS cameras produce a slightly larger image than the same focal length on a 35mm camera. A 40mm lens is considered normal for an APS camera.

Short telephoto lenses (70mm to 135mm): For photographing people and isolating parts of the landscape, short telephotos are perfect. They are light and compact enough to hand-hold and provide a more natural perspective than longer telephotos.

Medium telephoto lenses (180mm to 300mm): With these lenses (see Figure 4) you begin to see significant magnification of the subject, allowing close views of animals that are not too afraid of humans, or candid shots of people. Occasionally, a distant part of the landscape can be captured with a medium telephoto, but you must be careful that atmospheric haze doesn't cloud the image.

Figure 4
A medium telephoto lens.

Long telephoto lenses (400mm to 1,200mm): Look at any publicity shot of a wildlife photographer—he or she will

be posed by a motor-driven SLR, attached to a monstrous telephoto lens. It's very impressive, as are the shots possible with such a chunk of glass. However, long telephoto lenses (see Figure 5) are heavy, expensive, and require considerable experience to use effectively. A long telephoto should be the last piece of equipment on a beginning outdoor photographer's list.

Zoom lenses: A zoom lens (see Figure 6) can span a range of focal lengths. For example, a wide-angle zoom might be 17mm–35mm, another zoom might cover 28mm–70mm, and a telephoto zoom might be 70mm–210mm or even 100mm–300mm. The range covered by a single zoom lens is constantly expanding—you can now buy a zoom that goes from 28mm all the way to 300mm.

In times past, zooms suffered from distinctly inferior optical quality, and by the strictest standards, they still won't match a fixed focal length lens for sharpness. But modern optical construction and exotic glass have reduced the gap to an insignificant one, as long as you buy a name brand zoom. Most professionals count on zooms to produce publishable work for them, and I think they're the way to go for a beginning outfit as well.

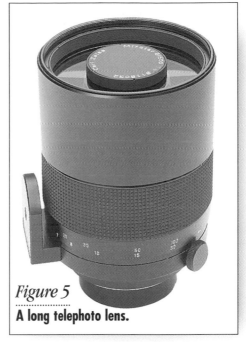

Figure 5
.................
A long telephoto lens.

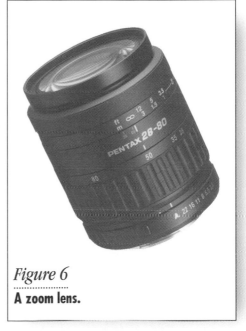

Figure 6
.................
A zoom lens.

Macro lenses: Most new outdoor photographers want to capture that sweeping landscape or the wolf peering around the tree. But a whole world of photographic opportunities exists right at your feet, and a macro lens (see Figure 7) is the way to capture it. A macro lens allows extreme close-ups of flowers, insects, and other minute subjects. Macro is usually defined as at least half life size (or 1:2); that is, the image of the subject on the film is half the size of the subject. Many macro lenses can produce a 1:1 image—the image on the film is the same size as the object.

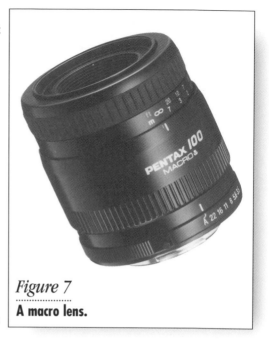

Figure 7
A macro lens.

Teleconverters: A teleconverter attaches between the lens and the camera, increasing the lens's focal length (and reducing its maximum aperture). Teleconverters commonly come in 1.4x and 2x versions. As an example, a 300mm f/4 lens becomes a 600mm f/8 lens with a 2x teleconverter attached. Teleconverters are a quick and inexpensive way to get what is in effect an extra lens; however, they do reduce image quality slightly (except perhaps with APO versions, see later) and also reduce the amount of light the lens gathers. Still, used with care they can be effective tools.

Lens Characteristics

When you shop for lenses for your SLR, you'll see a huge variation in price. One 70mm–210mm zoom might cost $150, another might be $1,000. The explanation lies in the construction of the lens.

All camera lenses are made up of several individual lenses, or elements. The number and quality of elements in the lens, their size, and the type of coatings on the glass surfaces determine the quality of the finished image—and the price of the lens. Let's look at some characteristics.

Lens speed refers to the amount of light the lens transmits to the film. A "fast" lens lets in more light than a "slow" lens, thus allowing you to take pictures in dimmer light without using flash or to use a faster shutter speed to freeze action. In general, the bigger the objective (front) element on the lens, the faster it is. The speed is referred to by the lens's maximum *f-stop*, which is the focal length of the lens divided by the diameter of the front element. The lower the number, the faster the lens. For example, in a normal, 50mm lens, f/1.2 or f/1.4 is fast, while an f/2 is only fair. On a telephoto lens, however, the objective lens has to be a lot bigger to let in the same amount of light. A 300mm lens of f/4 is about standard, while an f/2.8 is very fast. The objective lens on a 300mm f/2.8 lens will be huge, and the whole lens might weigh six pounds or more. Even more massive are those supertelephotos used by top wildlife photographers, such as the 600mm f/4, with an objective lens roughly a half a foot in diameter.

A fast lens is good, but it's also expensive and heavy. On the other hand, a lens that's too slow will make it difficult to take pictures in anything but bright sunshine. Some inexpensive 70mm–210mm zoom lenses have maximum apertures in the f/5.6 range, which is pretty pokey for that focal length. A better compromise would be an f/4. Other zooms have a variable maximum aperture: At 70mm it might be f/4, but only f/5.6 at 210mm.

Aberration correction: When standard optical glass is used in a lens, the three primary colors—red, blue, and green—will not focus in exactly the same plane. This condition is known as *chromatic aberration*, a slight lack of sharpness sometimes apparent as a colored fringe. It's more of a problem with longer lenses and zooms; it can be corrected by the use of special optical glasses. The letters APO, ED, LD, or SD indicate lenses that employ elements made of fluorite or other low-dispersion glass. These lenses are more expensive, but they produce a noticeable improvement in color sharpness and brightness.

Coatings: A lens made of uncoated glass would reflect a large portion of the light entering it and scatter even more light inside the lens, thus producing a dark, fuzzy image. So manufacturers coat the surfaces of the lens elements with ultrathin chemical coatings designed to increase the light transmission and reduce scattering. The better the lens, the better the coatings—and the better the final image.

Shopping for a Lens

Many beginners are tempted to buy the fanciest camera they can afford, and then skimp on lens quality. I recommend doing just the

opposite. Stick with lenses made by your camera manufacturer or, if you're really on a budget, those from respected aftermarket companies, such as Sigma or Tamron. If you have the money for the APO versions, you won't be sorry you spent it—but don't assume the normal versions will produce inferior images. It's a matter of small but noticeable improvement.

Don't be tempted by the do-it-all 28mm–300mm zooms. You're far better off in both quality and lens speed to buy a wide-angle zoom, such as a 20mm–35mm, plus a medium telephoto zoom, such as a 70mm–210mm. Those two plus a 50mm macro lens (which doubles as your normal lens), would form a very versatile starter outfit.

Don't be *too* tempted by the ultrafast lenses. A 70mm–210mm f/2.8 is a great lens, but it's big, heavy, and only gives you one more stop of light than the same lens in an f/4. The lighter lens might serve you better, especially if you do a lot of hiking.

Accessories

Flash

Many people suppose flashes (see Figure 8) are strictly for taking pictures at night, but they have many daytime uses as well. When it's bright and sunny but your main subject is in shadow, you can use *fill flash*, which illuminates the dark areas to match the surrounding light. Flash can also add a highlight in the eyes of an animal subject, making it appear more vibrant. Whether they are built into the camera body

Figure 8
A flash unit.

or designed to attach to the hot shoe (the bracket with electrical contacts on top of the camera), most current flashes are controlled completely by the camera's metering system as it reads light through the lens. The designation TTL refers to this through-the-lens metering capability.

Autowinder or Motor Drive

These devices automatically advance the film after each exposure, so you don't have to move your eye away from the viewfinder to cock a lever. They also allow a rapid sequence of shots of a moving animal (although the noise can sometimes frighten the same animals). A motor drive is faster than a winder—some can crank off seven shots per second or more. Many SLRs have a winder or motor drive built in; on others you can add an external drive if desired.

Keep in mind that, while they are useful, drives can eat an amazing amount of film, so use them judiciously.

Strap

A strap is a seemingly insignificant item that contributes immensely to your comfort in the field. The thin strap that comes with most cameras quickly begins to chafe on a long hike with a zoom lens attached. Buy a wide aftermarket strap, which distributes the load better. The popular neoprene models are very comfortable, although personally I don't like the way my camera bounces when using them. I prefer a nonelastic strap of nylon.

If you are very active, an elastic chest harness or strap is a useful accessory. It prevents the camera from banging against your chest while hiking or climbing.

Tripod

I'll go out on a limb here—next to your lenses, your tripod might be the most significant contributor to sharp photographs. Whenever possible, I use a tripod to ensure that my camera stays rock steady during the exposure.

When selecting a tripod, consider the use to which you'll be putting it. If you backpack or hike a lot, you'll want a lightweight tripod; if you do most of your photography within sight of the car, you can go heavier. In general, the heavier the tripod, the more steady it is, so there's obviously a trade-off to consider if you'll be carrying it any distance. The best strategy is to buy a good brand and stick closely to the manufacturer's weight limits. I like Bogen tripods (see Figure 9) for

reasonable cost versus quality; if you've got the money, Gitzo makes some very nice models.

If you want to try close-up photography, look for a model with legs that can spread flat, to get the camera closer to the ground. Reversible center columns can accomplish the same thing, but I think they're a pain to use, and they make composition more difficult.

Just as important as the tripod is the head to which the camera actually attaches. For inexpensive tripods, a standard pan-and-tilt head, with three knobs to control the movement, works just

Figure 9

A Bogen tripod.

fine. Ball heads are simpler to use, but stay away from cheap ones, which can be jerky and won't support a heavy camera and lens effectively. The very best are the Arca-Swiss type heads, but they are *really* expensive. A nice feature is a quick-release mechanism—a small plate that attaches semipermanently to the camera and snaps into a recess in the tripod head. It makes mounting the camera fast and easy.

Bean Bag

As a surprisingly effective alternative to a full tripod, a bean bag can be any variation on a bag filled with beans—a sock filled with rice, a stuff sack filled with sand, etc. Draped over a car door or a rock, the bag steadies your camera quite well and can be placed on the ground for macro shots. It can also be hung from the centerpost of your tripod to add stability in wind.

Blower Brush

My favorite lens and camera cleaner consists of a little rubber bellows attached to a soft brush, available for about $5.00. This will suffice for about 90 percent of your equipment cleaning needs.

Lens Hoods and Caps

Lens hoods help reduce *flare* and *ghosts*. Flare occurs when the camera is pointed at an oblique angle to the source of light, resulting in a washed-out look to the image. Ghosts are those annoying spots of light from the sun that sneak into the edges of photographs.

Lens caps protect those vulnerable objective lenses from dust or scratches. My lenses have lens caps attached whenever I am not actually composing a photo. Lenses in the camera bag should also have a rear cap attached.

Cable Release

Another, very inexpensive, way to help you make sharp photographs, a cable release eliminates the tiny bit of vibration added by your finger when you depress the shutter. They are only useful when the camera is on a tripod. A standard, mechanical cable release screws into the top of the shutter release button. Many new electronic cameras take electronic "cable" releases that attach to a socket.

Tip: **If you don't have a cable release, you can cheat by using the camera's self-timer to release the shutter, which also removes your finger from the camera during exposure.**

Film

Any novice looking at the hundreds of film choices available for a 35mm camera will be understandably confused. However, it's easy to narrow down your options to just a few.

Color slide films: Also known as transparency or color reversal films, slide films are usually indicated by the word *chrome* in the film name (Kodachrome, Fujichrome, etc.). Slide films form an image by producing a color positive on an emulsion (the dull side of exposed film)—a light-sensitive coating on a transparent backing (the shiny side). Slide films produce an image you can view directly, through a viewer or a slide projector. You can also make prints from slides, although it is more expensive.

Slide films have limited *exposure latitude*, the range of over- or underexposure within which you still get acceptable results. Slide film must also be matched to particular light—a daylight film is intended for sunlight or electronic flash and will produce greenish-tinted results under artificial (incandescent) light; you must switch to the proper film for indoor photography.

Color negative film: Indicated by the word *color* in the name, color negative films produce a negative image from which prints are made directly. They have a wider margin for error than slide films, but of course they cannot be projected.

Which color film to use: If you are interested only in color prints for the family album, color negative film is your best choice. You'll get fine results at a moderate cost. However, if you have any aspirations at all to publish your work or produce slide shows, you'll need to use slide film. Virtually all the photographs you see in magazines and books are taken from transparencies because the process is very straightforward.

Compared with negative films, slide films offer better contrast between specular highlights (a directional reflection, such as the sparkle of an ice crystal on a snowbank) and diffuse highlights (a scattered reflection, such as the bright white of an entire snowbank). This separation of highlights, combined with higher color saturation and greater tonal range (four times that of a print), give projected color transparencies a "live" three-dimensional look that can't be equaled by color prints.

For beginning photographers, one of the greatest advantages of slide films is the direct feedback they provide regarding exposure. Unlike negative films, where multiple stages of processing and printing introduce a number of variables beyond the photographer's control, a transparency is separated by only one step from your exposure decision—what you see is what you shot.

Another advantage to transparency films is lower cost. If you compare the cost of a roll of transparency film and processing with the cost of a roll of negative film, processing, and prints, transparencies come out on top (this doesn't include the occasional cost of making a print from a slide).

Film Speed

Film, like lenses, comes in different speeds—slow film needs more exposure time, fast film needs less. Just to make things confusing, however, the numbering system is the opposite from lenses: faster films have higher numbers. *Film speed* is designated by its *ASA* or *ISO* number: A 25 or 50 speed film is slow, while a 200 or 400 speed film is fast, allowing flashless photos in dimmer light. Each jump in speed, from 25 to 50 to 100, 200, and 400, indicates a film that is twice as sensitive to light. Of course, just as with fast lenses, there is a trade-off. In this case, image quality decreases as the film speed increases.

Film *emulsion*, the light-sensitive coating on film, is not a perfect

substance. It has a grain that is noticeable under high magnification. Fast films have larger grain structure, which becomes noticeable as the image is enlarged. Films in the ISO 400 range are marginal for producing publishable photographs. Films of 25 or 50 speed produce fine-quality images with virtually no distinguishable grain; however, such films require fast lenses or longer exposures.

WHICH FILM TO USE?

I suggest starting out with a 100 speed film, which balances fine grain with good speed. Kodak's Elite Chrome or their new E100VS are both excellent, as is Fuji Astia or Provia. For scenics, a 50 speed film, such as Fuji Velvia, offers stunning results, although it sometimes produces exaggerated skin tones on people.

Once you've found a film or two you like (and each film has its own personality), stick with them and learn them inside and out, so you'll be able to predict results and know how to get the most out of the product.

Basic SLR Gear

When you're just starting out, you don't want to drop loads of money on equipment—and all the best equipment in the world won't make up for bad technique. On the other hand, good equipment will complement your efforts, ensuring that your vision translates to film accurately. Fortunately, the best way to ensure success in outdoor photography is to begin with just a few pieces of quality gear. You'll save money and can augment your outfit later when you're sure of the direction your photography is taking.

The photography market is a strange entity. List prices offered by camera manufacturers bear no relation whatsoever to the heavily discounted prices typical at camera outlets, often 50 percent less than "suggested retail." So shop around—but be cautious of mail-order houses. Some are reputable, some not. Ask whether the product is an official import or something called "gray market." If the latter, it means the store has imported the item on its own, not through the manufacturer's official channels. In such cases the factory warranty is often invalid (though not always). I've bought gray market lenses before, because lenses rarely go wrong, but I'd hesitate to buy a gray market electronic camera loaded with microchips and motors.

A good local photo store is really your best friend when shopping

for your first outfit. There you can try the cameras and ask advice. Buying at least your first camera and lenses from a helpful neighborhood store is worth the extra cost.

I'd rather not suggest specific starting outfits down to brand and model, because it is risky—models change frequently, and technology advances rapidly. Instead, I'll give you a range of prices at which you should expect to be able to find suitable camera and lens models that fit your needs. One benefit of the rapid advances in camera and lens manufacturing techniques is that prices have changed very little over the past several years, while capabilities have gone way up.

Starting Outfit

◆ **One camera body** ($300-$700): You'll get an autofocus camera, probably with a built-in winder or motor drive, possibly a built-in flash as well. You should have a choice of autoexposure modes, with manual exposure too.

◆ **Wide angle zoom lens:** For most use, something in the 28mm-80mm range works great ($130-$200). If you're interested in landscape photography, you might want something that goes wider, for example, 20mm-35mm ($350-$500).

◆ **Medium telephoto zoom:** 70mm-210mm is the standard here, and anything near this is a very versatile choice ($175-$350). Some are advertised as "macro capable," but these are really just close-focus lenses.

◆ **Macro lens:** For most use, a 50mm lens is a good choice—and the least expensive ($250-$300). Longer versions, better for shy subjects, cost more.

(Prices for lenses span a range from aftermarket to camera manufacturer's own lens. For APO lenses, double the listed prices.)

◆ **Flash** ($100-$350): A flash from your camera maker will work automatically with the camera. The more you spend, the more powerful the flash, meaning two things: It will reach out farther, and the flash duration is shorter, which will freeze movement, such as that of a bird's wings, better.

◆ **Tripod with pan or ball head** ($100-$200)

◆ **Case** ($50-$200)

◆ *Accessories:*
 Cable release
 Blower brush
 Lens tissues and fluid
 81B filters
 Skylight filters
 Graduated filter and holder
 Extra batteries

Advanced SLR Gear

How do you know when you're ready for additional equipment? If you work with your starter outfit for two weeks and think you need more, you're not trying hard enough. After you've used the basics for several months and brought home images that please you in all the categories that interest you—scenics, people, action, and wildlife—then it's time to think about what gear might further your goals.

◆ *Additional camera body:* You might want the same model you already have, which makes switching between the two simple, or you might spring for a more professional model (see Figure 10) with additional features. The flagships from Canon and Nikon can run about $2,000. Such cameras feature extremely fast motor drives, numerous automatic features, and many user-programmable functions. Remember, however, while they might make some shots easier to get, the images they produce will be of no higher quality than those made with a basic model.

Figure 10

A professional-level SLR camera.

◆ **Superwide-angle lens:** Lenses of less than 20mm focal length produce striking images, with huge foreground objects just inches from the lens, and sweeping backgrounds. They're used mostly for scenics, but I've seen people, action, and wildlife shots that are outstanding taken with them. The shorter the focal length, the more difficult it is for the manufacturer to control aberrations, so the price goes up quickly. An aftermarket 17mm lens will run around $375, while a 17mm–35mm APO zoom from a camera maker could be over $1,000.

◆ **Long telephoto:** A 300mm f/4 is a perfect starter lens for wildlife photography. Most manufacturers are concentrating on APO versions of this length to maximize image quality. An aftermarket 300mm APO lens can be had for around $600; a manufacturer's own lens for $200 to $400 more. The good thing about an APO lens is that you can add an APO teleconverter to it and get a longer lens at a fraction of the price of two lenses. A 1.4x APO teleconverter ($150–$400) will turn your 300mm f/4 into a very good quality 420mm f/5.6 lens.

◆ **Supertelephoto:** "Let's see, do I want a new car or a new lens?" Well, it's not quite that bad, but a new camera manufacturer's brand 600mm f/4 lens will set you back about $9,000; a 500mm f/4.5 about $5,500. A 500mm f/4.5 from a good aftermarket maker such as Sigma is still over $3,000. Obviously, you need to be committed to serious wildlife photography to consider such a beast—and then you'll need the proper tripod to hold it (see the following). The big telephotos are capable of making dramatic images when in the right hands, but they're still no substitute for patience and a thorough knowledge of the animal.

◆ **Professional tripod:** Once you begin using lenses beyond 300mm or so, you'll find the support provided by a budget tripod inadequate to prevent image shake. You'll need to move to something sturdier, with a better head. My idea of the ultimate tripod starts with the Gitzo Mountaineer carbon fiber tripod, an extremely sturdy unit that weighs 30 percent less than a comparable aluminum model and costs about twice as much—$500 or so. The best head I've seen is the Arca-Swiss B1 ball head with quick release, an astoundingly smooth but strong ball head that costs around $300. A company called Really Right Stuff makes superb quick release plates to fit the Arca-Swiss head.

Buying Used Equipment

One way to get the equipment you want without going broke is to buy used. Most photo magazines, especially *Shutterbug*, list hundreds of used items each month.

In general, I would avoid buying a used camera until you're very familiar with the equipment. Cameras are incredibly complex tools and, while extremely reliable, are nevertheless subject to electronic failures. Don't count on in-house warranties—I once sent a camera back for in-house service because the shutter was sticking. When I got it back, it was completely ruined. Investigation revealed that someone had doused the shutter mechanism with lubricant, which fried the electronics. The company refused to admit any of its technicians could have done such a thing. It was pointless to pursue the matter legally because the company and I were separated by twenty states.

Lenses are another matter. As long as a lens has been reasonably cared for, there is very little chance of anything going wrong. Often you can find used lenses in perfect condition for 60 to 70 percent of the new price. This savings becomes really significant when you're shopping for heavy artillery, such as those big telephotos.

Make sure the business or party from whom you order any used equipment has an unconditional trial period, during which you can send the item back for a full refund. When you receive the equipment, immediately run a roll of film with it, testing as many different functions as you can.

Understanding Exposure

Aperture, Shutter Speed, and Film Speed

A photograph is created by light; capturing exactly the right amount of light is what constitutes proper exposure. There are three aspects to exposure, and you've already been introduced to one of them: film speed. Shutter speed is the amount of time the shutter is open to let the light through the lens aperture and onto the film. Because film speed is set once you put the roll in the camera, the only variables you have to worry about while taking photographs are shutter speed and aperture.

Aperture

The front, or objective, element on your lens determines the maximum amount of light that can pass through the lens. But inside the lens is a mechanism, called the *diaphragm,* which adjusts the size of the aperture, reducing or increasing the amount of light passing through the lens as needed. On the lens is a moveable ring with f-stops marked in stepped sequence. For example, a 50mm lens with a maximum f-stop of 1.4 might be marked 1.4, 2, 2.8, 4, 5.6, 8, 11, and 16. If you look through the lens (without the camera attached) while moving the aperture ring, you'll see the diaphragm get smaller as you go from 1.4 to 16. Each step to a larger number, known as stopping down, halves the amount of light getting through the lens, while each step to a smaller number, known as opening up, indicates a doubling of the light (a lens at its maximum aperture is said to be "wide open" in

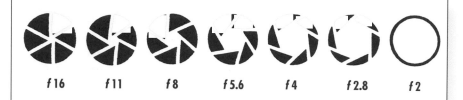

f 16 f 11 f 8 f 5.6 f 4 f 2.8 f 2

Figure 11
As the f-stop numbers get smaller, the lens opening gets larger.

photographer's parlance). Remember: As the f-stop numbers get larger, the lens opening gets smaller (see Figure 11). Don't be confused because the numbers don't double with each step of increase.

Why have a variable aperture? Because aperture controls depth of field, the range in front of and behind your focusing point within which everything will be acceptably sharp. A large aperture produces a shallow depth of field; a small aperture creates a deep one. Sometimes you want as much of the scene as possible to be in focus, such as in a landscape; sometimes you want to pick out a specific subject and leave everything else out of focus. Another thing to keep in mind is that no lens produces its best results wide open. Maximum optical performance is usually achieved in the middle apertures, around f/8 or so, depending on the lens.

Shutter Speed

The *shutter speed* is marked in seconds and fractions of a second. Like f-stops and film speed, shutter speeds increase or decrease by a factor of two. Each step to a shorter shutter speed halves the length of the exposure, while each step to a longer speed doubles the length of the exposure. A shutter speed dial might span a range from 4 (four seconds), 2, 1, 1/2 (one-half second), 1/4, 1/8, 1/15, 1/30, 1/60, 1/125, 1/250, 1/500, 1/1000, 1/2000, or even faster. Most shutter speed dials also include B, which means the shutter stays open for as long as the shutter release is held down.

Variable shutter speeds allow you to choose a fast speed (1/250 or shorter) if you want to stop action when the light is bright enough, or a slow one if the light is dim, or you want to use a small aperture to get maximum depth of field.

22

All these numbers sound very confusing, but there's an utterly simple concept underlying the whole mess. Just remember to think of the light and exposure in terms of stops—a doubling or halving of the light. Each jump, whether in film speed, f-stops, or shutter speeds, represents one stop, and each is interchangeable (see Figure 12). That is, if your camera says the proper exposure is, say, f/8 at 1/125 shutter speed, you can get exactly the same exposure using f/5.6 and 1/250 (larger aperture and shorter shutter speed), or f/11 and 1/60 (smaller aperture and longer shutter speed). You can achieve the same result by changing film speed—going from an ISO 50 film to a one-stop-faster ISO 100 means that, for the same exposure reading, you can either use a one-stop-faster shutter speed or a one-stop-smaller aperture.

Tip: If you're hand-holding your camera instead of using a tripod, your shutter speed should be roughly the corollary of your lens length or faster to minimize the effects of camera shake. So, for a 50mm lens, use 1/60 or faster; for a 300mm, use 1/250 or faster; etc. The exception is for wide-angle lenses—stick to 1/60 or faster.

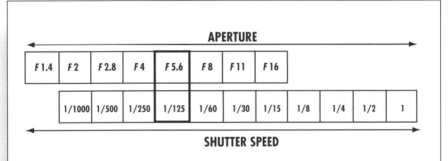

Figure 12

Both shutter speed and aperture occur in equal one-stop increments. Once an exposure reading has been taken, adjustments can be made that will preserve the proper exposure. For example: If your reading indicated an exposure of f/5.6 at 1/125, any of the other settings aligned in the figure would provide the same exposure. With this in mind, you could easily adjust the shutter speed to 1/15 second to create a motion blur without having to take another reading. As long as the aperture is set to the corresponding f-stop, f/16, the original exposure will be maintained.

Remember to think in stops. That's the best way to understand the total exposure of a scene. A white subject reflects about 90 percent of the light that falls on it, while a black subject reflects only about 3 percent. If brightness increases by one stop with each doubling of reflectance, you can see there is a maximum five-stop range from a black object to a white one *in the same light* (3 percent, 6 percent, 12 percent, 24 percent, 48 percent, 96 percent). Scenes that contain actual sources of light (such as the sun or a lamp shining into the camera) or uneven lighting (full sun and deep shadow) can extend well beyond that five-stop range. So proper exposure involves a compromise between all the ranges of brightness within a scene.

What Your Meter Sees

Your camera's meter measures the brightness of a scene. The brightness depends on two factors: the amount of light that falls on the scene and the amount of light the scene reflects. An average scene, one that contains a mix of tones from white to black, will reflect 18 percent of the light hitting it. (The color of the subject doesn't matter, only its tone. To visualize tones, try to imagine the scene as black and white.) This average reflectance is called the middle tone or *18 percent gray*—halfway between black and white.

The middle tone is the standard used to calibrate meters and film speeds. Your meter is designed to interpret everything as middle-toned. If you take a reading of any single tone between pure black and pure white, your meter will select an exposure to reproduce it as 18-percent gray.

Determining the Best Exposure

To arrive at the proper exposure for any scene you, or your meter, must decide which part of the scene is middle-toned and calculate the exposure from that. Green grass, tree trunks, or foliage in uniform light are all middle-toned, and a quick reading of a scene filled with these subjects will almost always produce an acceptable image. But what if you meter a sailboat dominated by the brilliant white of an unfurled spinnaker? Your meter will assume the sail is middle-toned and produce a gray, underexposed image. What if you meter a child hanging from a rope swing with a bright blue sky in the background? Your meter will be overwhelmed by the bright sky, and the child—the point of interest—will be underexposed, likely just a black silhouette. Your camera's meter, even if it is one of the most sophisticated AE systems, is not foolproof.

When you look at a scene that exceeds the five-stop range of brightness we discussed earlier, your eyes automatically adjust as you look around within the scene. You can look at people standing in the shade and see the color of their skin, then look out at a bright white sunlit beach and see it normally. But no photographic film can do the same thing. Color slide films can only reproduce about a five- to six-stop range of brightness, so the photograph of such a scene will be a compromise between a properly exposed beach and properly exposed faces in the shade. When such great variation is present, you must be the final arbiter of what the "right" exposure is.

Camera Metering Systems

The first through-the-lens (TTL) camera meters were rudimentary averaging systems—the camera simply determined the exposure that was correct for the average brightness within the scene. Later, manufacturers began offering spot meters, which only measured a central spot within the viewfinder. These meters made it much easier to manage tricky subjects, because you could point the spot at whatever you wanted exposed correctly. Today, many cameras have evaluative metering systems, which measure the brightness within different areas of the picture, then decide how to set the exposure, based on a computer model of various situations.

Manual versus autoexposure systems: The meter on a manual camera simply tells you what it has determined as the correct exposure; you set the aperture and shutter speed yourself. An autoexposure (AE) camera can do one of three things (many allow you to choose any of the three): It will set the shutter speed for you after you have set the aperture, it will set the aperture after you have set the shutter speed, or it will set both for you. In the last case, aperture and shutter speed are balanced according to a preset program; some cameras allow you to customize the program to, for example, choose higher shutter speeds to freeze action, or smaller apertures for increased depth of field.

The capabilities of autoexposure (AE) cameras grow steadily more sophisticated with the introduction of each year's models. Most allow you to select from a variety of metering patterns. Many compensate for backlit subjects. Some can automatically bracket your exposures. The manufacturers tout each system's ability to solve tricky exposure situations, playing to the beginning photographer's understandable desire to sidestep the learning curve and let the camera do the thinking.

Don't fall for it. No metering system is infallible, nor has one been invented that is capable of making an aesthetic judgment. The best AE cameras will produce a high percentage of technically correct exposures, but technical accuracy does not always produce the image you saw (or envisioned) when you composed the shot. Good photography is art, and no computer chip can produce art. Every photographer should have a basic understanding of exposure principles, so he or she can create an image rather than merely recording one. My advice is to practice with your camera's AE system to get to know its strengths and weaknesses, so you'll know when to use your brain instead of the microchip. Generally, I find AE modes most useful for shooting fast-moving action in scenes with no tricky lighting.

Manual metering with a spot meter: If your camera has a spot meter, it will normally measure an area about the size of the central split-image circle in the viewfinder. You can use this "spot" to measure the proper exposure for the area in the picture you have decided is the most important, even if it is brightly backlit or in deep shade. For example, if you're photographing people, you'll generally want their faces exposed perfectly, so you aim the spot at a face and see what the reading says. Once you've locked in the exposure, you can recompose the image so the face doesn't have to be right in the middle of the picture.

Close metering and substitute metering: If your camera lacks a spot meter, you can accomplish the same thing by moving very close to the subject and metering so the desired area fills the viewfinder. If you can't get that close, use a substitute—pick a nearby object that appears to be the same tone as your subject and meter off that.

Bracketing: When you're in doubt of the correct exposure, or if you're photographing a once-in-a-lifetime scene (such as a UFO hovering over your backyard), hedge your bets by using a range of exposures. You can do this manually, but many cameras now offer programs that will do it automatically for you, taking a series of three shots separated by one stop each, one "correctly" exposed, one underexposed, and one overexposed. One of the three will almost surely produce an acceptable image.

Tip: Overexposure means you've let too much light hit the film; *underexposure* means too little. On slides, which represent the direct results of your exposure, an underexposed image will be too dark, an overexposed one too light—just as you would think. But with print film it's just the opposite, because the development goes through an additional stage. A print that's too light indicates underexposure,

because the negative (the direct result of your exposure) will be too dark, indicating that not enough light gets through when the print is made.

Special Situations

Moving water: The movement of flowing water will be completely stopped at 1/2000 second. At 1/60, the faster portions of the stream will begin to blur. Shutter speeds from 1/8 second to several seconds will produce a soft, ethereal quality.

Fireworks: To capture nightime fireworks using ISO 100 film, set your aperture at f/8 or f/11 and the focus at infinity. With the camera on a tripod, set the shutter on B and hold it open for several seconds (with a cable release) while fireworks are going off.

Moon: For a full moon on a clear night, using ISO 100 film, expose at f/8 for 1/250 second. Increase the exposure one stop if there are clouds or haze. For a half-moon increase the exposure one stop; two stops for a quarter moon.

Aurora borealis: With ISO 100 film and the camera on a tripod, expose for 8 to 30 seconds with the lens wide open (f/1.4 to f/2.8).

Lightning: Select a location away from bright lights. Use a normal or medium wide-angle lens set at f/8 or f/11 with the camera on a tripod and the shutter set on B. Open the shutter, wait for a lightning strike or two, then close the shutter.

Sunrises and sunsets: Slight underexposure will increase color saturation and produce a richer, more dramatic image. A common exposure error when shooting sunrises and sunsets is gross underexposure caused by the brightness of the sun. To avoid this, select and meter the portion of the sky to one side of the sun that you want to reproduce as middle-toned. Then recompose the picture using that setting.

Rainbows: To increase color saturation, underexpose 1 to 1 1/2 stops depending on the darkness of the background sky (the darker the sky, the more you underexpose).

Water, snow, or bright sand: The high reflectance of light-colored surroundings will cause your meter to give an underexposed reading of a darker main subject. To correct this, either spot-meter the subject, substitute meter a middle-toned object, or increase by 1 to 2 stops an averaged metering.

Flames: With ISO 100 film set the shutter to 1/60 and the aperture to f/2.

Subjects illuminated by flames: With ISO 100 set the shutter to 1/8 and the aperture to f/2.

Fog: In dense fog with no sun, increase exposure 1 1/2 to 2 stops over your meter reading. In fog with visible sun increase by 1/2 to 1 stop.

Dark-skinned faces: Spot-meter the face if you can, then decrease exposure by one stop. With an averaged reading and a lighter background increase by 1 stop.

Birds in flight: The bright background of the sky will overwhelm the meter, resulting in an underexposed main subject. Take a reading off a substitute middle-toned subject in light shade (since the underside of the bird above you will be shaded) or open up an averaged reading 1 1/2 to 2 stops.

Composition

Good pictures are created, not found. Beginning with an understanding of exposure, the outdoor photographer must build an image out of the shapes, textures, colors, and movements of nature. On its most basic level, composition is simply the arrangement of elements in an image to create a pleasingly "balanced" picture. At its best, composition enhances the photographer's message, building an emotional as well as physical dimension in an image.

The Rule of Thirds

This most basic of composition techniques will help you visualize the underlying structure of good composition. Imagine that the viewfinder is divided in a grid of thirds (see Figure 13) along both the horizontal and vertical axes, forming nine equal rectangles. Use these lines as references for the placement of horizons or other large features. The points where the lines intersect can be used for the placement of the subject (a setting sun) or a critical element of the subject (the bright eye of a deer).

Remember: The Rule of Thirds is a useful aid to understanding composition, but rules are made to be broken. Don't be afraid to experiment with compositions that don't fit the model.

Figure 13

To gain a better feel for composition, select several pictures from a magazine. Using a ruler, draw lines dividing each picture into thirds. You'll find that the major elements of the pictures fall roughly along the areas defined by the lines.

Common Composition Errors

No clear subject: Most pictures need a central element to attract the viewer's attention. The eye should be immediately drawn to the central element, then move to secondary elements.

Subject too small: This common problem has two easy solutions–either move closer to your subject or use a longer lens. Getting close to the subject is particularly important when working with a wide-angle lens.

Subject centered: Very few compositions work well with the main subject exactly centered in the frame. Position the subject so that the direction of action or *the potential for action* is toward the open part of the image area.

Horizon out of level: Pay attention to the horizon line and keep it square. Few things detract from an otherwise good picture as quickly as a tilted horizon. Also remember the Rule of Thirds and don't place the horizon line in the middle of the photo.

Lack of scale: Use perspective to give a sense of depth and scale. Foreground elements that give scale to the subject are particularly important when composing scenics.

Too many elements: Strive to simplify your images by asking yourself what you can eliminate from the scene. Try horizontal and vertical framing. Isolate your subject from competing elements in the scene by changing your position and lenses.

Distracting backgrounds: When the subject is set against a busy background, use a large aperture to create shallow depth of field and blur the distracting patterns. Avoid elements that lead the viewer's eye out of the picture. Also, beware of background elements that strangely bisect the subject. The classic example is the tree growing out of your friend's head.

Tip: About two-thirds of all published 35mm photographs are vertical compositions, so don't neglect vertical shots.

Depth of Field

Although depth of field is controlled by aperture, it's also controlled by distance. Using a 50mm lens as an example, if you focus on a subject 6 feet away at f/2, only those parts of the scene about 4 inches in front of and 6 inches behind the focusing point will be sharp. At the same distance but at f/16, everything from 4 1/2 feet out to almost 10 feet will be sharp. Now, move the focusing point out to 15 feet away. At f/2, your depth of field extends from around 14 feet out to 17 or 18 feet—significantly deeper than the 10 inches you got at 6 feet. But at the same 15 feet at an aperture of f/16, everything from 8 feet all the way to infinity will be in focus. All lenses have a depth-of-field scale on the barrel, which will help you decide on the correct aperture for your situation.

Tip: Depth of field extends farther behind the focusing point than in front of it. When using a small aperture to maximize depth of field, focus a little in front of the subject.

Depth of field versus focal length: Conventional wisdom says that wide-angle lenses have greater depth of field than telephoto lenses. That's true, *as long as both lenses are the same distance from the subject.* Take a picture of a bird from 20 feet away with both a 35mm and a 300mm lens, and the 35mm shot will have a greater depth of field— but of course the bird will be much smaller. If you move close enough with the 35mm so that the bird is just as big on the film as it is with the 300mm, the depth of field of both lenses will be exactly the same.

Depth of field preview: To allow as much light as possible through the lens while you are composing the photo, SLRs hold the lens aperture wide open, no matter what aperture you have selected, until the exact moment of exposure. This technique keeps the image bright, but only shows you the depth of field as it would be if you shot with the lens at its maximum aperture. The aperture preview lever manually stops the lens down to your selected aperture, allowing you to see through the lens what will be in focus in the final image. You'll see the view darken and the image sharpen through the viewfinder as you press the button or lever.

Light

L ight travels in waves along a straight path unless affected by *diffraction* (the spreading of light passing by an opaque body), *reflection* (the turning back of light), or *refraction* (the bending of light as it passes from one medium through another, as from air through a lens). Different wavelengths of light create the sensation of color for our eyes. The visible spectrum (see Figure 14) ranges from the shorter wavelengths of violet to the longer wavelengths of red. Not visible, but of interest to photographers, is ultraviolet (UV).

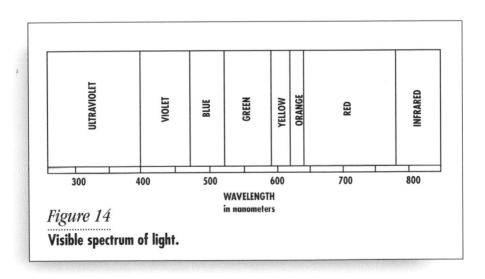

Figure 14
Visible spectrum of light.

Qualities of Light

Color Temperature

The color of light, or *color temperature,* is expressed in degrees Kelvin. An easy way to visualize color temperature is to imagine a piece of steel being heated in a forge. As its temperature rises, the steel's color shifts from red to orange to white to blue. Although we may think of blue as a "cooler" color than orange, on the color temperature scale blue is indicated by a hotter, or higher, temperature.

As light from the sun passes through the earth's atmosphere, it is scattered by gas molecules, water droplets, and particulate matter. *Scattering* (see Figure 15) begins as the light first enters the upper atmosphere. Here the shorter (blue) wavelengths are occasionally scattered by the sparse molecules of air. Some of the blue light is reflected down to earth, producing what we see as a blue sky. As the light continues its earthward journey, a portion of it encounters progressively larger particles in the form of dust, smoke, and pollen. These larger particles aren't selective, and all wavelengths are scattered equally, producing what we interpret as "white" light.

Atmospheric scattering is responsible for the various colors of natural light that the outdoor photographer encounters. The middle two-thirds of a clear day, when the sun is high and the light passes through the least amount of atmosphere, is standard daylight: 5,500 degrees Kelvin. The cooler cast of objects shaded from direct sun is the result of their being illuminated only by scattered light from the sky–the preponderance of blue light that gives it a characteristic "cool" look. On a clear day, open shade has a color temperature of 12,000 degrees Kelvin. The warm colors of a sunrise or sunset are the result of the increased scattering that occurs when the light travels a greater distance through the atmosphere. As the earth turns and the horizon rises to meet the sun, light passes through the atmosphere at an increasingly oblique angle, and more of the shorter, blue wavelengths are scattered. So the light appears progressively warmer as the mix of wavelengths reaching us contains proportionally more of the longer wavelengths of red and orange light. At sunrise and sunset the temperature of the light has dropped to 3,100 degrees Kelvin.

Hard and Soft Light

Another important quality of light is its character—its hardness and softness. The character of light is determined by the size of the light source relative to the subject, and its distance from the subject. The

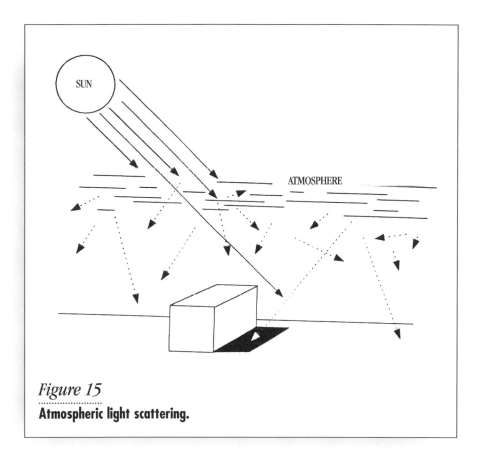

Figure 15

Atmospheric light scattering.

smaller and more distant the source, the harder the light. That is why sunlight on a clear day (from a large but extremely distant source) produces high contrast and sharply defined shadows, and sunlight on a cloudy day (from a close, large source: the diffusing clouds in the sky) produces low contrast and softly defined shadows.

Direction

The next quality of light relevant to the outdoor photographer is direction. The direction, or angle, of lighting helps determine the amount of information about form, texture, and depth contained in a scene. Sidelighting enhances the shape and texture of the subject. Frontlighting produces bright colors, but flattens texture and form by eliminating shadows and highlights. Backlighting gives the subject depth and produces bright highlights.

Using Filters

A filter is a tool for controlling the quality of light that reaches your film. Filters can be used to reduce reflection, subtly shift color values, reduce the overall amount of light entering the lens, or reduce the brightness difference between two elements in a scene.

The most common type of filter consists of a circular glass element set in a threaded metal mount, which screws to a filter ring on the front of the lens. Filters are available in a wide variety of sizes to fit different-sized lenses; their measurements are given in millimeters. Some large telephoto lenses have smaller filters that slide into a little drawer near the back of the lens.

When you mount a filter to your lens, take care to match the delicate threads and don't tighten it more than just snug. A filter wrench (available from photo stores) or a 4-inch-square piece of bicycle inner tube can be used to free a stuck filter.

I use filters when necessary to produce a desired effect (or protect against an undesired effect), but only when necessary. Each layer of glass you tack on the front of your lens reduces image quality by a tiny bit—it's silly to photograph with a $600 lens through a $20 piece of glass without a good reason. Never use more than one filter at a time.

With that said, there are a few filters that can be of real use to an outdoor photographer. (See Figure 16.)

Skylight 1A: Many photographers keep skylight filters on their lenses all the time, to protect the front element. There's some wisdom in that, but I keep my lens cap on when I'm not actually shooting, and that's even better protection. A skylight filter does add a very slight warming effect, improving skin tones and helping to reduce the excessive UV light at high elevations.

Warming filter 81B: One of the greatest problems when shooting on snow, particularly at high elevations, is the excessive amount of blue in the light. Ultraviolet wavelengths, already more intense at high elevations, combined with the predominantly blue reflections from snow, can give photographs an unnatural hue. This can also be a problem on overcast days when sunlight is filtered by clouds, in open shade, or on a sunny white beach. Sometimes a blue tinge accentuates the mood of the image, but at other times—particularly if there are people in the shot—it's best to correct the light. An 81B filter does so very effectively. It can also be used to enhance already-present orange and red hues, to intensify a sunset, for example.

Neutral density filter: A neutral density (ND) filter does exactly what its name suggests–it reduces the overall amount of light entering the lens without altering the color. It is useful in situations that call for longer exposure, such as for blurring the movement of water.

Graduated filter: This is one of my most used filters. It consists of a dark area (sometimes tinted but normally neutral) that fades into a clear area. When a bright sky overwhelms a dark foreground, a graduated filter will reduce or eliminate the difference, allowing a balanced exposure. The most useful graduated filters are square and slide into a holder on the front of the lens, so they can be slid up or down to adjust the division between light and dark. They come in different densities, designated by stops.

You must take care when using an ND filter so that the junction between light and dark looks natural. It works best when there is a natural definition, such as a horizon, to disguise the border. Remember to meter the scene and set your exposure before you install the filter. Generally, you'll want to meter the dark portion of the scene to expose correctly.

Polarizing filter: *Polarized light* waves, in contrast to scattered light, move only in a single direction. Polarization occurs in reflected light and open blue sky; it can wash out sky colors or blind the image with glaring reflections. A polarizing filter blocks polarized light, allowing only scattered light through. It can darken blue skies and reduce unwanted glare from water or glass. Polarizing filters are designed to rotate because the filter needs to be oriented in the correct direction

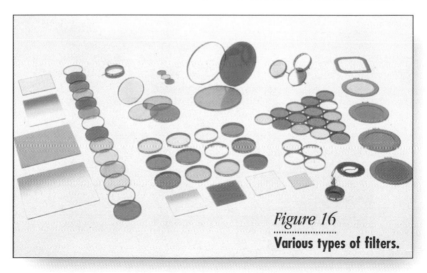

Figure 16

Various types of filters.

to block polarized light waves. The filters work best when at a 30- to 40-degree angle to the source.

Although polarizing filters can create dramatic images, they can be tricky to use, and they can reduce the total amount of light reaching the film by two to four stops. Standard polarizing filters are labeled "linear," but some autofocus cameras require a different type of polarizer, known as "circular." If your camera's instructions don't tell you which to buy, get the circular type, which works with any lens.

Subjects

Scenics

Capturing landscapes is the perfect way to begin nature photography. A landscape can't run away from you, and if your first tries don't produce good results, you can usually go back and try again.

In the majority of circumstances, the best time to photograph a landscape is right after sunrise or just before sunset. When I say "right after" or "just before," I mean it—often a minute or two will be enough to change the quality of light. A sun nearly touching the horizon produces a warm orange light that makes the land glow, and long, soft shadows that emphasize forms. Many landscape photographers visit a site two days in a row—one day to simply watch the light and select the right composition, the next to actually take photos.

Another advantage to photographing near sunrise and sunset is that the air is more likely to be still at those times—an advantage if you have grass or foliage in the frame and you're working with slow shutter speeds.

Always use a tripod. Usually, you'll want maximum depth of field for a landscape shot, and that means a slow shutter speed. A tripod is mandatory to ensure a crisp image. A cable release helps too. However, it's easier to compose the photograph with the camera hand-held first, then mount it on the tripod.

Experiment with camera position. Sometimes having it at standing height produces the most natural result, but—especially with wide-angle lenses—a low camera aspect can create a dramatic effect,

making foreground objects loom large, while the background sweeps away in the distance. For such shots you'll need the smallest aperture you can use to keep everything sharp.

Experiment with lenses too. Wide-angle lenses are the landscape standard, but normal lenses and short telephotos can isolate features and bring distant mountains closer. These longer lenses are also useful when the foreground is unattractive and you don't want it in the picture.

Try including secondary objects in the foreground to frame the background and give it scale. Overhanging trees or rocks are examples—but people work well too, especially if they are doing something natural within the landscape, such as hiking or climbing.

Watch closely for different lighting between the foreground and background, and use a graduated filter if necessary to balance the exposure. And keep that horizon level!

People

People, other than, perhaps, grizzly bears, are the trickiest subjects to photograph well, and the most likely to be critical of the results. The overriding concern is to make them look natural and at their best. The following guidelines will help ensure frequent success:

Most important is lighting. Full, high sun will produce harsh shadows and squinty expressions. If you're posing your subjects, try to do so in indirect sunlight or open shade. If the shade is deep or the sky is cloudy, a warming filter will bring back pleasing skin tones. Also, in general, try to keep the camera at eye level with your subjects, which is a more natural aspect.

If you have to photograph in harsh sun, make sure everyone's face is fully lit. Get them to look down, then up at you just before you take the shot, which will reduce squinting. Watch for shadows from hats, which will completely black out faces. Either remove the hats, tilt them back, or use fill flash to light underneath.

Frame your shot carefully. If you're including the entire body, include the entire body—don't cut it off at the feet (or, worse, the forehead). If you're closer, crop the image at major joints of the body— the knees or the waist—or shoot what a sculptor would call the bust. If it's a single person (that is, just one, not an unmarried individual), use vertical composition if possible.

Finally, try to avoid static poses unless it's a "we were there" shot. Shoot candidly and unobtrusively as the subject is doing something. It often works to chat about what they're doing and ask questions to put them at ease. Continue talking and shooting until the tension of the first few shots has worn off, and you'll likely get better results.

Figure 17
A photographer shooting in the field.

Wildlife

Most outdoor photographers dream of catching those dramatic closeups of wildlife—the wolf peering around the tree, the peregrine falcon feeding her young, the hummingbird suspended near a flower. So they hit the trail, hoping for the perfect opportunity. Invariably, they are disappointed with the results—either they see no animals at all, or the shots of the ones they do see are distant, blurred, and distinctly undramatic. At this point they either give up or decide that the key is one of those monster lenses. If it's the latter, and they're well-off, they might drop five grand on a 600mm f/4—and *still* be unhappy with the results.

The reason is simple: The key to successful wildlife photography is not equipment, it's an understanding of the animals, combined with a massive amount of patience. The more you know about your subject's life history, habits, food, and peak activity times, the more opportunities you'll get to see them, and the more patience you have, the closer you'll get to them.

My best advice here is, start small. It's tempting to head right out

after snow leopards or cape buffalo, but there's a whole world of wildlife waiting just outside your own town, or even in your backyard. Birds are excellent subjects for photography, because they're easily attracted with food, and with a little habituation will tolerate humans' very close presence. A couple of feeders in your yard, placed close to natural perches, will offer great opportunities using a medium telephoto lens in the 300mm range or even a 70mm–210mm zoom. Another astonishing universe is available if you have a macro lens: butterflies, spiders, and the like are often easy to get close to. Beginning with subjects such as these, you will gain much insight into general animal behavior.

Tip: Here's a (near) surefire way to get some good starter bird photographs in your backyard. First attract birds for several weeks with food and water (visit a local bird store for advice). Then wire or nail a natural-looking stick to a post or limb on a tree, so one side is lit by the morning sun. Smear peanut butter or suet (or seed in a drilled hole) on the back side for several days, until birds get used to feeding there. Then set up your camera with your longest lens (a 210mm should be enough) to frame the front of the stick and the birds who perch there regularly. Set everything in advance, including exposure and focus, so that you can sit quietly by the camera early in the morning and just click the shutter with a cable release when a bird hits the right spot. It might take time for the birds to get used to you, but persist. Try fill flash too, to enhance the natural light.

When you want to shoot larger animals, again, the best places to try first are where they are habituated to humans, such as in well-used national parks. Even then, use patience. Don't walk directly toward animals, but obliquely close the distance between you. If the animal shows signs of nervousness, stop and wait until it calms down and goes back to feeding, or whatever it was doing. And don't think you always have to fill the frame with the animal; look for attractive compositions within its habitat. A small elk in the middle of the frame will look like you didn't get close enough, but a small elk on the edge of a meadow will look like an elk and its home. Remember to leave more space in front of the animal than behind, so it doesn't appear to be walking out of your picture.

When you want to go after wilder subjects, a few tips will help increase your chances.

Observe: While hiking through an area, watch your surroundings closely. Move quietly, and stop frequently to look and listen. Even better, pick a spot at the edge of a habitat—along a stream, the perimeter of a

B A S I C E S S E N T I A L S

clearing—and sit. You'll notice the activity of birds, small mammals, etc., pick up after you've stayed quiet for a few minutes. If an animal you'd like to photograph appears, freeze and watch it. If it doesn't seem to notice you, wait until it looks away and slowly move your camera into position. Remember that animals are more likely to see sideways movement than movement straight toward or away from them.

Blend in: Wear drab clothing made of natural fibers if possible. Although many mammals don't see color well, most birds do, and if birds are alarmed by your presence, their cries will alert other animals.

Watch the wind: Mammals are alarmed by scent more than anything else. Stay downwind of the area you're investigating; if you're moving, move upwind.

Watch the time: Peak activity time for most animals is around dawn and dusk. Get out early and be in place by sunrise.

Be considerate of the animals: Some of the most respected wildlife photographers in the world have fallen victim to the determination to get a photo at all costs, even if it means harassing the animal. Don't do it. The underlying guideline for all wildlife photography should be respect for the animal.

Action

The trick to successful action shooting is to *anticipate* the action. You can blaze away with your motor drive in the hopes of accidentally capturing the decisive moment, but you'll do better to figure out in advance where and when that moment will occur and be ready to snag it with one perfect shot. For example, if you're shooting a group of kayakers running a rapid, look for a wave or falls that provides an exciting view as the boats go over. Meter one paddler, then shoot as the next one goes over (if you have a manual-focus camera you can prefocus at the right spot).

Often the best way to give a sense of action is not to freeze it with a high shutter speed, but to allow a little bit of blurring, especially in the background. The way to do this is by using a slow shutter speed and *panning* with the subject—move the camera along with the subject, keeping it moving even as you trip the shutter. For a fast-moving object, such as a race horse, a shutter speed of 1/125 is slow enough to slightly blur the background; for a kayaker, 1/30 or 1/15 is better. Really slow speeds of 1/15 or 1/8

will create streaked arcs of movement in the subject and a completely obscured background.

Macro Photography

Ignoring the world at your feet will blind you to a whole universe of fascinating subjects to photograph. An outdoor photographer's portfolio is vastly more interesting with a mix of scenics, wildlife and people shots, and macro studies.

The least expensive way to experiment with close-up photography is with add-on lenses that screw to the filter ring of your standard lens. They can produce decent results, especially if stopped-down two or more stops from your lens's maximum. Other options are a bellows or extension tubes, both of which fit between your standard lens and the camera. But the best option is a real macro lens.

Most macro lenses focus down to a reproduction ratio of 1:2, which means that the image on the film will be half the size of the actual object. For a majority of subjects, such as butterflies and flowers, this is more than enough. Other macro lenses go down to 1:1—the image on the film is the same size as the object.

The standard macro lens is 50mm, and this length can also be used as your normal lens if you need to economize (the only difference being that macro lenses are usually a bit slower than standard lenses, say f/2.8 instead of f/2 or f/1.4). For shy subjects that might flee at the close approach of a giant (to them) lens element, a better choice is a 100mm or 200mm macro, which will allow you to stay a few inches farther from the subject. You're essentially employing a minitelephoto lens.

One problem with macro photography is depth of field, which can be only fractions of an inch deep if the lens is wide open. There are two ways to avoid this—one is to always use a tripod and cable release, which will allow slower shutter speeds and thus smaller apertures; the other is to use a flash. A combination of both is ideal. Special flash brackets that position a flash properly for macro photography are available. The best setups use two flash units, which produce a very even, natural-looking light with no harsh shadows. Such a setup is a fully professional outfit and costs a fraction of what a big wildlife telephoto lens does, yet offers endless possibilities for exploration.

When taking photographs in natural light, avoid bright sunlight, which causes the same problems with small subjects as it does with big ones. Fortunately, the sun is easier to control over such a limited area—you can shade the subject with an umbrella or a makeshift

cover. You can then add light as, and at what angle, you need it by using a soft reflector to bounce subdued sunlight in from the side.

Fill Flash

Fill flash used to be an art, but with modern TTL flash systems it's much easier. Whenever I'm in a situation with less than perfect light, I try fill flash for at least some of the shots.

The trick to fill flash is getting the light to look natural. The concept of "fill" light means it's just enough to brighten the dark areas without overwhelming the shot with fake-looking light. If your camera has an automatic fill-flash program, it will usually do this correctly on its own. Experiment with the camera to see how well the program works. If the fill light is too bright, many flashes allow you to reduce the intensity of the flash one stop at a time. Or, you can trick the flash by setting its film speed dial to one-stop faster than it is set on your camera. That will also reduce the intensity by one stop.

Fill flash can be used with telephoto lenses as well, to fill in wildlife subjects and add a "catchlight" in the eye, giving the animal a more lifelike appearance. Most standard flash units will work out to at least 30 feet, and the TTL exposure system will automatically compensate for the longer lens you have in place.

Tip: Red-eye is caused by the flash being too close to the center of the lens, so that the light from the flash reflects the lining of the subject's eyes back onto the film. It's not much of a problem to eliminate red-eye with fill flash in daylight, because the subject's pupils are contracted. At other times keeping the flash as far as possible from the lens, by using an extended bracket, for example, will minimize the possibility.

In the Field

Film Care

All film boxes are marked with the expiration date of the film, after which it shouldn't be used (although of course there's some leeway built in). The expiration assumes storage at under 70 degrees; if you live in a warm climate, film will degrade faster. Here in Arizona, I take my film out of the boxes (but leave it in the plastic canisters), put it in plastic freezer bags, and store it in the refrigerator. When I take it out to use, I always let the bag and contents warm up to ambient temperature before I open it, to eliminate condensation.

Incidentally, when you buy film, you'll soon be introduced to "professional film," which supposedly *must* be kept refrigerated. Actually, professional film is often exactly the same film sold as plain old consumer film. The difference is simple. All film undergoes changes in its chemical makeup as it ages. Like fine wine, there is a recognized peak to this aging, during which time the film's performance will be at its very best. Professional film is sold right at this peak and kept refrigerated to slow down further aging. When you buy consumer film, you might be getting it before, at, or after the peak.

While traveling, avoid exposing film to high temperatures or extreme fluctuations. Use a small cooler to store film in your vehicle. When backpacking, store film deep in your pack, wrapped in some sort of insulation. Never leave your camera or film in direct sunlight. Process film as soon as possible after exposure to avoid image fading

and color shifts due to temperature changes and humidity.

When traveling by air, always take your camera bag and film as carry-on luggage. Arrive early at the security gate and ask to have your bag hand-inspected to avoid the low-powered X-ray machine. Remove all your film cassettes from the plastic canisters and arrange them in freezer bags, where they're easy to inspect. At all costs avoid putting film through as checked baggage—new X-ray machines for checked bags are much more powerful than the old ones and *will* damage your film.

Camera Handling

My cameras have taken some truly horrifying whacks over the years, against rocks, cockpit rims, the floor of my old Land Cruiser (emergency stop to miss a rattlesnake), you name it. Each time, I looked down expecting to see flying camera parts, but none of my cameras has ever even stopped functioning. That's a tribute to the stout construction of top-quality cameras, but it's *not* my recommended way to treat equipment.

Whenever possible, your cameras and lenses should be protected in a padded case. Dozens of styles are available, but for outdoor photography a few stand out as most useful. For hiking and climbing with just one camera and a few lenses, a photo fanny pack works very well, leaving both hands free and the equipment instantly accessible (see Figure 18). Another option is the individual "holster" arrangement around a

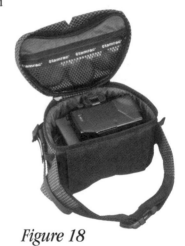

Figure 18
...................
Tamrac Hip Pack, model 702.

padded belt. The holsters are made of neoprene and provide good protection with excellent access. For a more comprehensive system, photo backpacks that will hold two bodies and a dozen lenses plus lunch and drinks are available.

Tip: A friend of mine once went cross-country skiing with a camera and one of those cheap bottled-water containers from the convenience store in the same fanny pack compartment. A tumble resulted in a split

bottle and a soaked camera, I mean paperweight. Use good water containers while hiking with cameras and separate them, anyway.

For nonhiking use I like the standard "pro" style cases, such as those from Tamrac (see Figure 19) and Lowe Pro. Their main compartments are easily custom-fit to your own needs, and the accessory pockets in the lid and around the perimeter swallow all kinds of stuff. Although the black cases look sharp, buy a light color to minimize heat buildup inside.

My own traveling case is possibly the ultimate in protection. It's a Pelican 1520, a stout, completely waterproof (and thus dust- and sandproof) case molded of ABS plastic, with an O-ring gasket seal around the lid. The case comes with a sectioned foam filler that you can pluck sections from to cradle your equipment. I've replaced the foam with an Omni case from Lowe Pro—a soft, padded case designed to drop into the Pelican or to be used on its own when waterproof protection isn't needed.

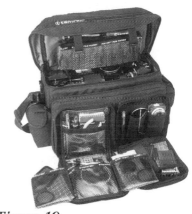

Figure 19
...................
Tamrac Pro System 10, model 610.

When the camera is actually around your neck, ready to use, it's much more vulnerable. There are neoprene socks that snap off quickly to put around it, but personally I find them to be inconvenient. I just leave my cameras naked—except for the lens cap, which stays on until I raise the camera to my eye–and try to avoid the worst knocks. A harness-type strap that holds the camera close to your chest helps quite a bit, but it is only suitable for one camera.

Very few modern SLRs require you to manually set the ISO speed or thread the film leader in the takeup spool when loading a roll of film. Most now have a digital icon that tells you the film has wound properly once you close the back. So loading involves nothing more than dropping in the cartridge and extending the film leader across the back to an index mark. Always load and unload film in the shade if at all possible to reduce any chance of stray light fogging it. Even shading the process with your body is better than nothing.

The best way to hold the camera is by supporting it underneath with your left hand, cradling the lens with your fingers. If you're using a manual focus lens, this grip allows you to focus without changing

Photography in the Outdoors **49**

position. Your right hand grasps the right side of the camera, finger on shutter button. For vertical compositions you just rotate the whole arrangement counterclockwise. Never let a heavy lens hang unsupported from the camera body.

Whenever possible, brace yourself to ensure a steady hold on the subject. Leaning back against a tree is a good way to gain support, so is sitting on the ground with your arms resting on your knees. But your best bet is to use a tripod, if possible.

Camera and Lens Cleaning

Dust, sand, and water are more insidious dangers to cameras than massive whacks. Dirt inside a camera can scratch the film, ruining entire rolls unbeknownst to you—until you return home from Africa and have the film developed ("Whoops, guess I need to go back"). Dirt in or on the lens will drastically reduce the quality of your pictures and can permanently scratch the glass or coatings.

However, improper cleaning can be just as damaging to a camera as the original contaminant. The last thing you want to do is grind dirt farther into the lens or into crevices under your shutter release.

The best way to begin cleaning is to not touch the camera or lens at all. A compressed air canister, available at camera stores, will safely remove a majority of surface dirt from camera and lens. I use the refillable kind, which costs less in the long run, but a compact disposable canister is easier to carry. Even when working with just air, use caution—don't blast delicate interior mechanisms, such as the mirror hinge behind the lens mount, with the full force of the can. Keep the canister upright to avoid spraying the propellant rather than the air.

The next step is to use a brush. I use a synthetic paintbrush with its handle cut short to clean off my camera bodies (exterior only). I never use this brush on my lenses, but instead use a camel's hair brush with a rubber bellows, which allows me to combine gentle sweeping with puffs of air.

Only if there is a smudge on a lens surface is more needed. Use a drop of lens cleaner made for camera lenses on a lens cloth made for camera lenses to gently swirl away the smudge. Never touch lens surfaces with your fingers, and never *ever* touch the mirror surface with your fingers.

Weather

Of all the hazards facing your camera, water is the proverbial angel of death. One drop on the microchip that controls all those fancy functions and you might as well get out a pencil and sketchpad if you

want memories of your trip.

To be fair, an occasional sprinkle on your camera is unlikely to cause a disaster, but you definitely should avoid water, or even dampness, as much as possible.

Extremes of heat and cold are also bad for the health of your camera. Heat can melt necessary lubricants, alter film color, and degrade images on exposed film. Cold is just as inconvenient. It can freeze film, making it brittle and impossible to load or unload; reduce the efficiency of batteries, causing cameras and winders to stop dead; and, if the air is very dry, encourage static sparks that leave your film looking like it was struck by lightning.

The solution is to only take photographs in great weather. Just kidding. The solution involves taking a few precautions.

Use a dessicant: A dessicant absorbs moisture, pulling it away from vulnerable equipment and film. Most new cameras come with a small packet of dessicant inside, but you can buy larger and more effective packets at photo stores. I put a couple in each camera bag, and one in each bag of film when traveling. Occasional recharge in the oven according to instructions keeps them effective.

Prevent condensation: Anytime you spend time in the cold, then move into a warm environment, moisture will condense on the cold metal, glass, and plastic of your equipment. Avoid it by carrying a few large Ziploc bags and putting the equipment inside while still in the cold. Keep the bag sealed until the contents have plenty of time to warm up.

Use an umbrella: A compact umbrella is not only perfect for photographing in rain or snow, it can also be used to shade your equipment—or a macro subject—from sun.

Use an underwater housing: Professional photo sources, and some dive shops, sell soft

Figure 20
Underwater camera housing.

underwater housings made by Ewa-Marine (see Figure 20). They look like glorified Ziplocs, but are actually heavy-duty housings custom-fit to each camera model, which allow full use of the controls and can be completely immersed. A hardened glass cover fits over the lens, minimizing image degradation. Models that will take a flash and a zoom lens are available. These housings are perfect for really wet sports, such as river running and kayaking.

Use a skylight filter and lens hood: If there's a chance of blowing rain or snow reaching your lens, a skylight filter will intercept it, so you don't have to keep wiping the actual lens surface. The filter will also warm colors in stormy scenes. A lens hood adds additional protection.

Always carry spare batteries: Spare batteries are vital any time, but especially in cold, which affects the performance of any battery, even the powerful lithium cells now standard in most cameras. If you plan on doing a lot of cold-weather photography, consider buying a camera with a mechanical shutter, which will work without batteries.

Test your camera's cold weather performance: If you're planning an extended trip in cold weather, find out how your camera performs in low temperatures before you leave home. Seal camera and lens in a large clear plastic bag and place them in a cold (0 degrees Fahrenheit or below) freezer overnight. In the morning, check the shutter and film advance (motor or lever) through the bag to see if they still work. If not, ask your local camera repair shop about replacing the lubricants with newer types that are less sensitive to cold. You can have your camera winterized, a process by which the lubricants are either replaced with low-temperature-only types or simply removed, but it's expensive, and you obviously have to have the lube replaced when you get home.

Avoid static: The electronic motors in your camera are a source of static in cold, dry weather. If your camera has a manual lever film advance in addition to the motor, use it instead. If not, keep the motor drive or winder on its lowest setting.

Don't use your breath to blow snow off your camera and lens: Snow will melt and freeze along with the moisture in your breath, a headache if it interferes with the mechanism and potentially damaging if it gets inside. Use a brush to remove snow. Accidental condensation is best removed quickly with a lens cloth before it has a chance to freeze.

Warm the film, but keep the camera cold: Film should be kept inside your parka, close to your body, so it doesn't freeze. Your camera,

however, once it's cold, should be left cold as long as you're outside. Trying to warm it intermittently will only increase the likelihood of condensation.

Cover exposed metal: Tripods will chill your hands quickly—a piece of foam water pipe insulation or one of the nice padded kits available from photo shops will improve handling and make the tripod easier to carry.

Wear gloves: My favorite gloves for cold-weather photography are the fingerless ones that have a hinged mit to cover your fingertips when you're not using them. In very cold weather, I add a thin polypropylene glove underneath, which doesn't affect dexterity much at all.

Camera First Aid

The key to dealing with drips, sprays, and splashes is to not force the water deeper into the camera. If there is any risk of water getting inside, remove the batteries immediately. Use a soft, pure cotton rag to gently blot up drops of water—don't wipe—and follow with Q-tips for hard-to-reach spots. When you can get to shelter, rewind the film, open the back and remove the lens, and inspect for any water inside. Dab away any you find, then pack the camera in a plastic bag with a container of dessicant and leave it overnight.

If your electronic camera has been thoroughly drenched or immersed in freshwater, it's probably ruined. If it's a mechanical camera, there's a fair chance of saving it. Either way, the only chance of salvation, believe it or not, is to remove the batteries and film and completely immerse the camera in freshwater until you can get to a repair shop. The reason is that corrosion is the greatest danger, and corrosion occurs when the wet metal is exposed to air. If, on the other hand, the camera has had a subsurface encounter with saltwater— well, remember that new model you saw at the camera store, the one with predictive autofocus, twelve-frame-per-second motor drive, and a built-in espresso maker? You just got the perfect excuse to buy it.

Appendix

Troubleshooting Problems

Totally Black Pictures

◆ Film didn't wind.

◆ Check film take-up spool.

◆ Check for proper film loading/threading.

◆ Check winder/motor drive.

Too Light or Too Dark (underexposed or overexposed)

◆ Wrong ISO setting: Check film/setting.

◆ Faulty aperture diaphragm: With lens off camera, hold lens to light—not sun—and look through lens as you operate aperture setting ring.

◆ Faulty shutter: Remove film and lens, leave camera back open, fire shutter.

◆ Faulty meter: Use "Sunny 16 Rule" to check meter—in bright sunlight the shutter speed equals the film's ASA if the lens aperture is set at f/16.

◆ Exposure compensation on: Check exposure compensation setting.

◆ Faulty lens/camera connection: Check mechanical connections/electronic contacts.

- ◆ Cold shutter or aperture diaphragm: Warm camera.

- ◆ Weak batteries: Replace batteries.

- ◆ Full-frame flare: Check lens hood; watch for sun in perimeter of view.

Dark Areas

- ◆ Corners dark: Vignetting.

- ◆ Lens hood encroaching on view: Check for correct lens hood.

- ◆ Filter mount encroaching on view: Using too many filters; filter mount or step ring too thick.

- ◆ Poor lens/extension combination: Use less extension or try another lens.

Partial Exposure

- ◆ Faulty shutter: See repairman.

- ◆ Faulty mirror bounce: See repairman.

- ◆ Too many exposures: Watch frame counter.

- ◆ Faulty winder/motor drive connection: Clean contacts.

- ◆ Strap or hand in the way: Be careful not to block lens.

Lines

- ◆ Dark line running lengthwise full-length, same distance from film edge, occurring on more than one roll: Burr on pressure plate—blow and dust clean.

- ◆ Line running lengthwise full-length, same distance from film edge, occurring on only one roll: Grit in film cartridge felt, processing error.

- ◆ Light line running lengthwise full-length, same distance from film edge, occurring on more than one roll: Burr or grit on film gate—blow and dust clean.

- ◆ Light-colored lines like lightning along film edge: Static discharge—rewind slowly in cold, dry weather.

- ◆ Dark-colored uneven lines: Hair or fuzz in film compartment—blow and brush clean.

◆ Uneven lines, light or dark, running length of film: Dust or grit in film compartment—blow and brush clean.

Out of Focus

◆ Poorly focused: Focus more carefully; check *diopter correction* eyepiece (an eyepiece that can be used to compensate for astigmatism); change viewing screen.

◆ Camera shake: Hold camera more securely; use tripod; use faster shutter speed.

◆ Subject movement: Use faster shutter speed.

◆ Condensation on lens (cool or warm): store camera and lens in sealed plastic bag until warmed to ambient temperature; use desiccants.

◆ Loose lens element or lens mount: Check lens, lens mounts.

◆ Faulty film pressure plate: Check for loose plate/uneven pressure.

◆ Dust on lens: Clean regularly; use lens cap.

◆ Improperly cleaned lens: Use lens solution; clean carefully.

Glossary

Angle of view: The angle between two lines drawn from opposite sides of the image circle to the lens.

Aperture: The opening in the lens diaphragm through which light passes to the film.

ASA: The index of a film's sensitivity to light. The smaller the number the less sensitive the film. (Same as *ISO*.)

Chromatic aberration: The uneven focusing of primary colors that occurs as light passes through a glass lens. It can cause color fringing and a softening of image sharpness.

Color temperature: The color of light in degrees Kelvin. It is based on the color given off by heated iron, beginning with red at 1,500 degrees Kelvin, through yellow at 3,000 degrees Kelvin and white at 5,500 degrees Kelvin, to blue at 12,000 degrees Kelvin.

Depth of field: The zone of sharpness that extends in front and in back of a subject in focus.

Dessicant: A substance that absorbs moisture.

Diffraction: The bending of light as it passes an opaque body.

Diopter correction: Many cameras include an adjustable diopter correction eyepiece that can be used to compensate for astigmatism. If your astigmatism is listed at -.5 or less on your eyeglass prescription, you can use the diopter correction in place of your eyeglasses when looking through the viewfinder.

18 percent gray: Halfway between black and white–the middle tone–used to calibrate meters and film speeds. An average scene, one that contains a mix of tones from white to black, will reflect 18 percent of the light hitting it.

Emulsion: The light-sensitive coating on film.

Exposure latitude: The range of over- and underexposure within which acceptable results occur.

F-stop: The number indicating the size of the lens diaphragm opening (aperture).

Field of view: The circular area of view covered by a lens.

Fill flash: Type of flash used when it's bright and sunny but your main subject is in shadow. Fill flash illuminates the dark areas to match the surrounding light.

Film frame: The opening in the camera body that defines the shape of the image area on the film.

Film plane: The area where the image is focused.

Film speed: See *ASA* or *ISO.*

Flare: Washed-out look to a photograph caused when the camera was pointed at an oblique angle to the source of light.

Focal length: The distance in millimeters from the center of the lens to the film plane.

Ghosts: Annoying spots of light from the sun that sneak into the edges of photographs.

Image circle: The area of image projected onto the film plane by a lens.

ISO: The measure of a film's sensitivity to light. The smaller the number the less sensitive the film. (Same as *ASA.*)

Lens diaphragm: The iris-like lens mechanism that forms the aperture and controls the amount of light passing through the lens to reach the film.

Lens speed: The amount of light the lens transmits to the film. A "fast" lens lets in more light than a "slow" lens.

Neutral density filter: A filter that reduces the overall amount of light entering a lens without altering color.

Overexposure: Occurs when too much light hits the film.

Panning: Moving the camera along with the subject as you trip the shutter.

Pixels: Discrete bits of information found in digital images. The more pixels, the sharper the image.

Polarized light: Light waves moving primarily in one direction. Light is polarized when it is reflected by most surfaces except unpainted metal.

Reflection: The turning back of light.

Refraction: The bending of light as it passes from one medium through another, as from air through a lens.

Scattering: The scattering of light from its path by atmospheric gas molecules, water droplets, and particulate matter. The cause of a blue sky, for example.

Shutter speed: The length of time the film is exposed to light expressed in seconds and fractions of seconds.

Single lens reflex: Type of camera that enables you to actually look right through a single lens, by means of a prism and mirror.

Underexposure: Occurs when too little light hits the film.

Index

About the Author

Jonathan Hanson is a freelance writer and photographer whose articles and photographs have appeared in nearly two dozen publications, including *Outside,* and *National Geographic Adventure.* Together with his wife, Roseann, he has written and illustrated eight books on natural history and outdoor sports, including the *Guide to Outdoor Sports,* which won the National Outdoor Book Award in 1997. The Hansons live in Portal, Arizona, where they lead natural history and nature writing workshops.